People places things

PAINTINGS BY
Jane McNichol

Copyright © 2015 by Jane McNichol

All rights reserved. No part of this publication may be reproduced, distributed, or transmitted in any form or by any means, including photocopying, recording, or other electronic or mechanical methods, without the prior written permission of the author, except in the case of brief quotations embodied in critical reviews and certain other noncommercial uses permitted by copyright law. For permission requests, send an email to the author at janeboyart@gmail.com

Paintings and Text: Jane McNichol, janemcnichol.com
Book Design: Janice Cave, janice@cavecreative.net
Copy Editing: Meg Cave, cave2@comcast.net, Janice Cave

For more information about Jane McNichol's art, pricing and availability, please contact Jane at janeboyart@gmail.com or go to janemcnichol.com

Publisher's Cataloging-in-Publication data
McNichol, Jane.
People places things: Paintings by Jane McNichol / Jane McNichol; foreword by Linda Cooper

ISBN-13: 978-1519776778
ISBN-10: 1519776772

1. Arts 2. Artists 3. Painting 4. Oil Painting 5. Memoirs

To Jim, by my side throughout

Foreword

Jane and I have shared our lives since college when we both were majoring in art. Since then, among the joys that Jane has brought to me and to the world are her paintings – a record of things we have shared and things that only she has seen. Some are illustrative, some are suggestive. Each one tells of a moment or a day or a time.

– Linda Cooper, friend

Quinn's Lancaster

In 2014, my niece, Quinn McNichol, also an artist, hosted an exhibit of paintings in Lancaster. She included my "Six Flights Up" in the exhibit. After the show closed, I drove to Lancaster to pick up the painting and visit Quinn.

It's bitterly cold that day with frozen snow everywhere. We are exploring the back alleys of the city when we pass a small building painted orange. Quinn's darker orange coat is striking against the background of the wall. That image, to me, embodies her enthusiasm about beginning her life as an artist – and my excitement for her.

So begins a series of very different works – more personal and directly narrative. Unexpectedly, I'm now painting where I live instead of where I dreamed to be.

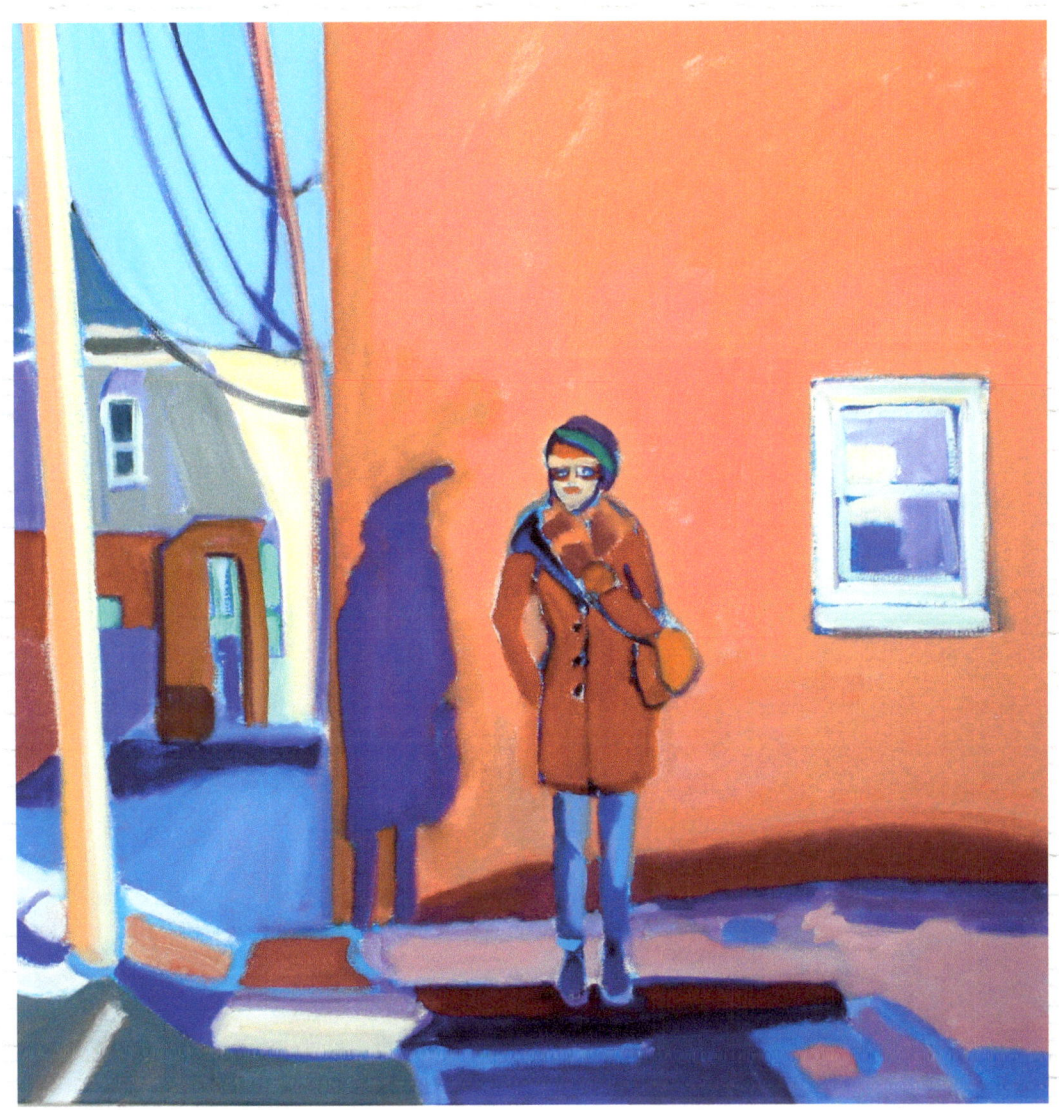

Six Flights Up (On Cover)

I moved to the East Village in downtown Manhattan in 1987. It wasn't a pretty place. So to escape the grit and congestion, I painted vast, far-off landscapes. Slowly, the neighborhood changed. And, over time, I have come to find beauty in my city environment.

This view is from my sixth-floor kitchen window. Looking down, I can see the top of a former bathhouse, now a beautiful rooftop deck. Embracing the scene and forming a dynamic composition is the colorful graphic pattern of windows and fire escapes. On my sill, in the foreground, are two potted plants.

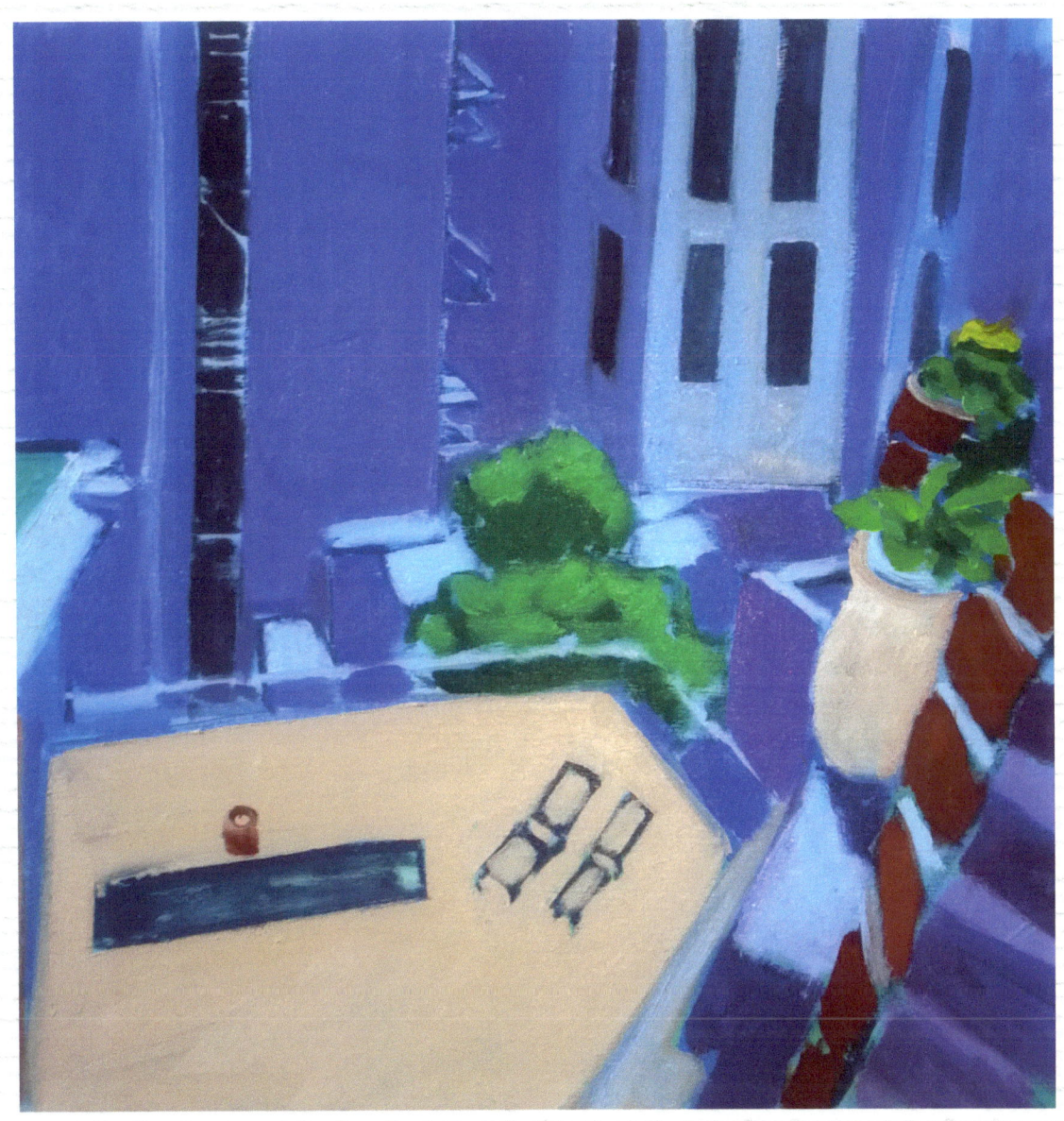

Williamsburg Bridge, Springtime

From 1998 to 2007, the view from my studio windows is the Williamsburg Bridge, a looming and constant presence. It carries a subway, walking and bike-riding paths – connecting Brooklyn to the East Village in downtown Manhattan, where I live. Such an expansive view provides much needed space, sky and light for this urban artist.

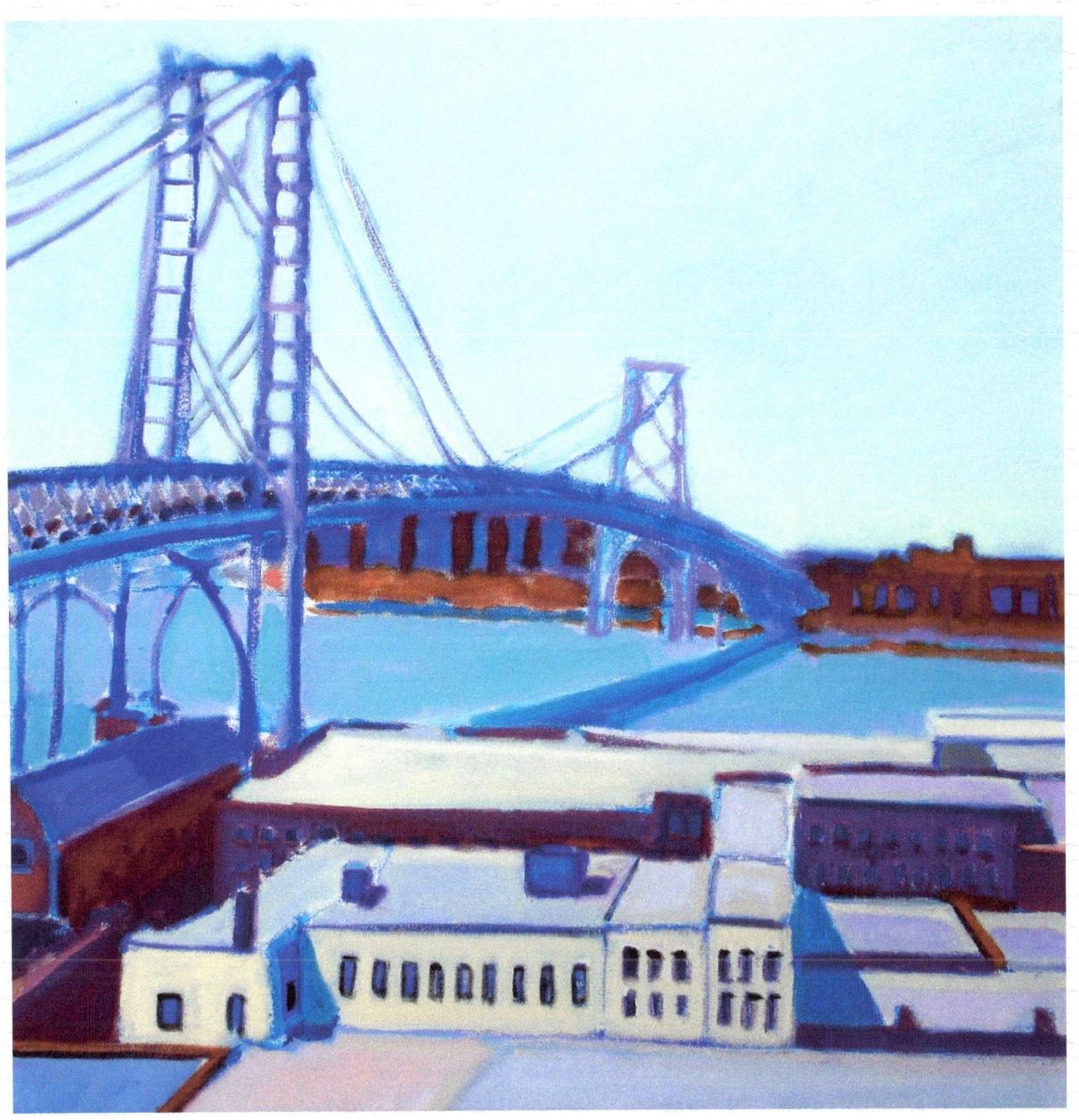

Wally in the Screened Porch

It is late August, and we are preparing a birthday brunch for Linda who lives in this Bucks County, Pa., home, with her husband Andre. Our friend, Wally, has taken a moment to put his coffee cup down and gaze at the verdant summer countryside. Surrounding the screened porch are Juniper trees, swaying field grasses and wildflowers.

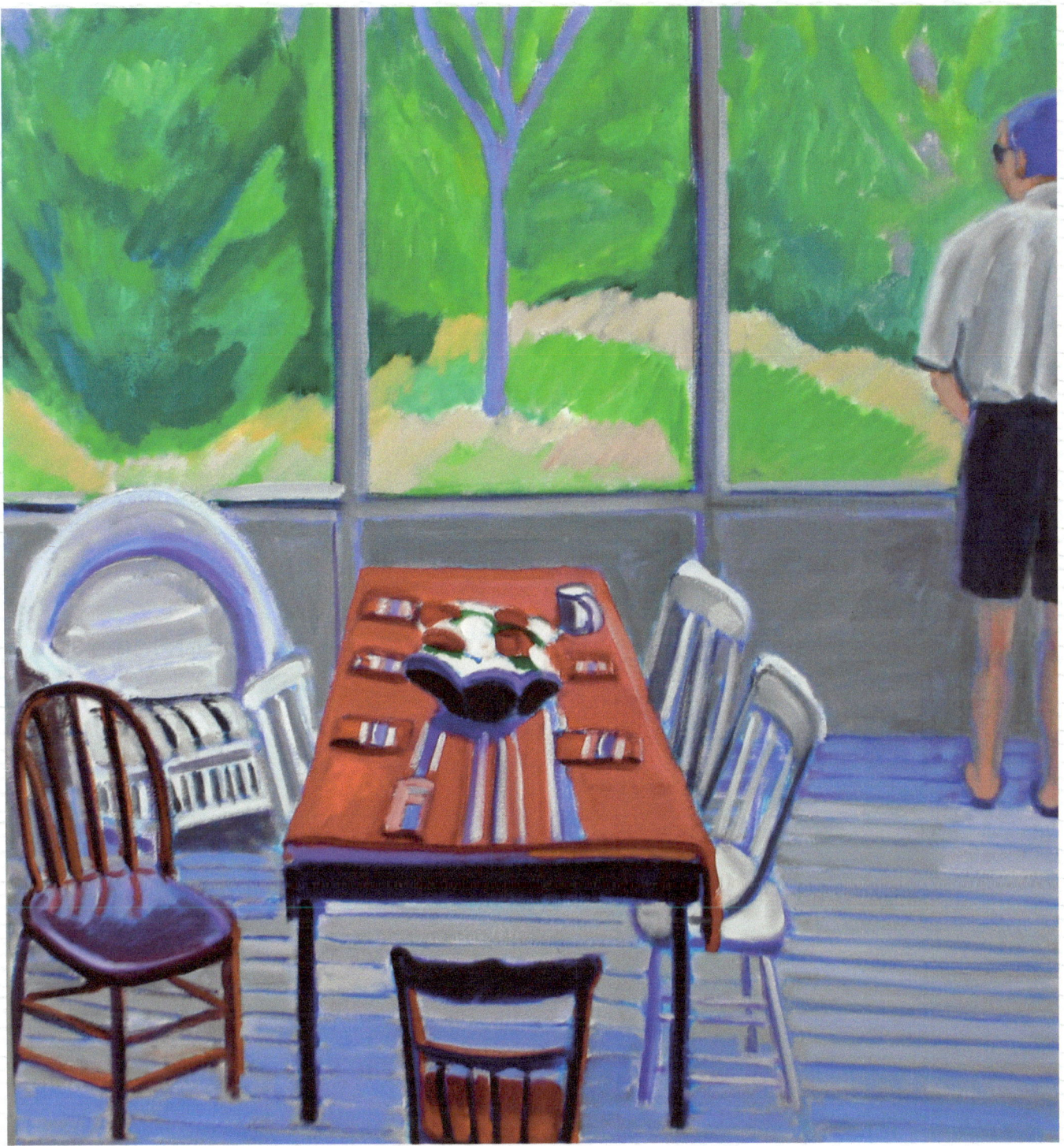

Swallowtail Base and Swallowtail View

Just off the Maine coast is the Swallowtail Lighthouse on Grand Manan Island, New Brunswick, Canada.

The lighthouse stands on North Head and is the first thing you see as the ferry approaches. Built from wood, the structure has endured many bruising storms over the years. But the island people maintain it meticulously and proudly, and heavy cables stabilize it to withstand blistering sea winds.

I climb to the top, and it's as if I'm on a boat out at sea with the Bay of Fundy stretched out all around me. The sunlight is clear and intense, affording an unobstructed view.

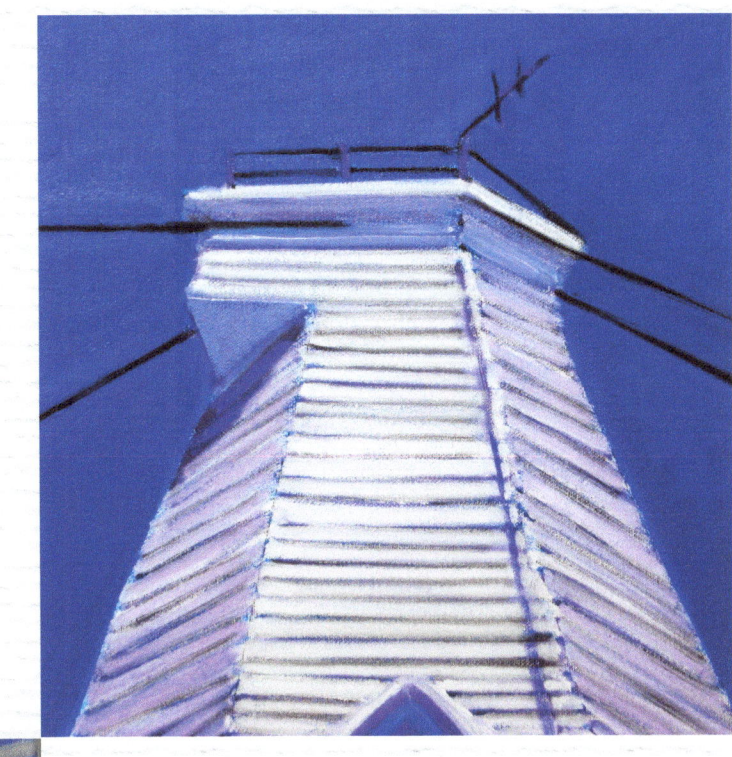
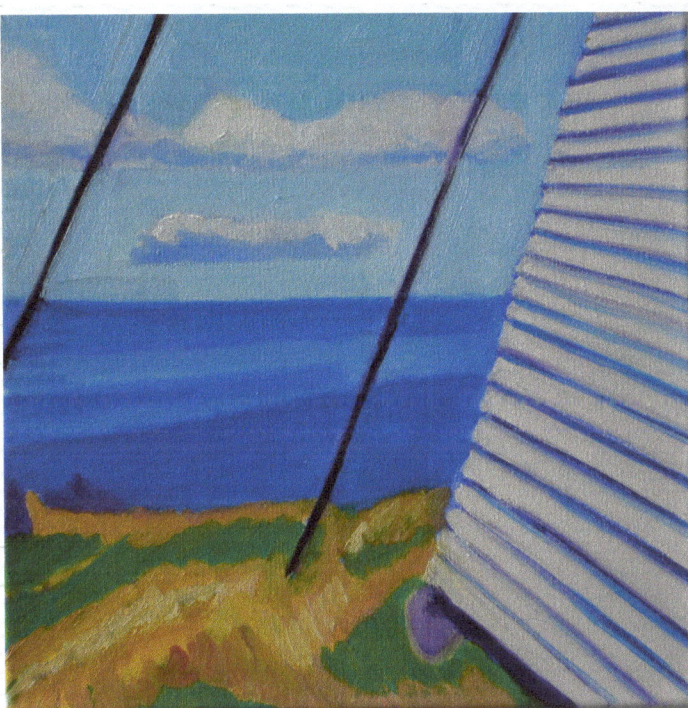

The Table Is Set

Dana and Howard Harrison are the most wonderful hosts. Dinner is always fresh, delicious and meticulously presented. When you arrive, drinks are served overlooking the Benjamin River that leads to the Eggemoggin Reach, Sedgwick, Maine. The house has large windows, and the light streaming in casts a beautiful glow. Hanging on the walls is their personally curated art collection.

This night the table is set for six. Stimulating and interesting conversation easily flows as the sun sets over the river. A delicious dessert is served, and at the end of the evening, we are sent on our way after an intimate and wonderful evening with these two dear friends.

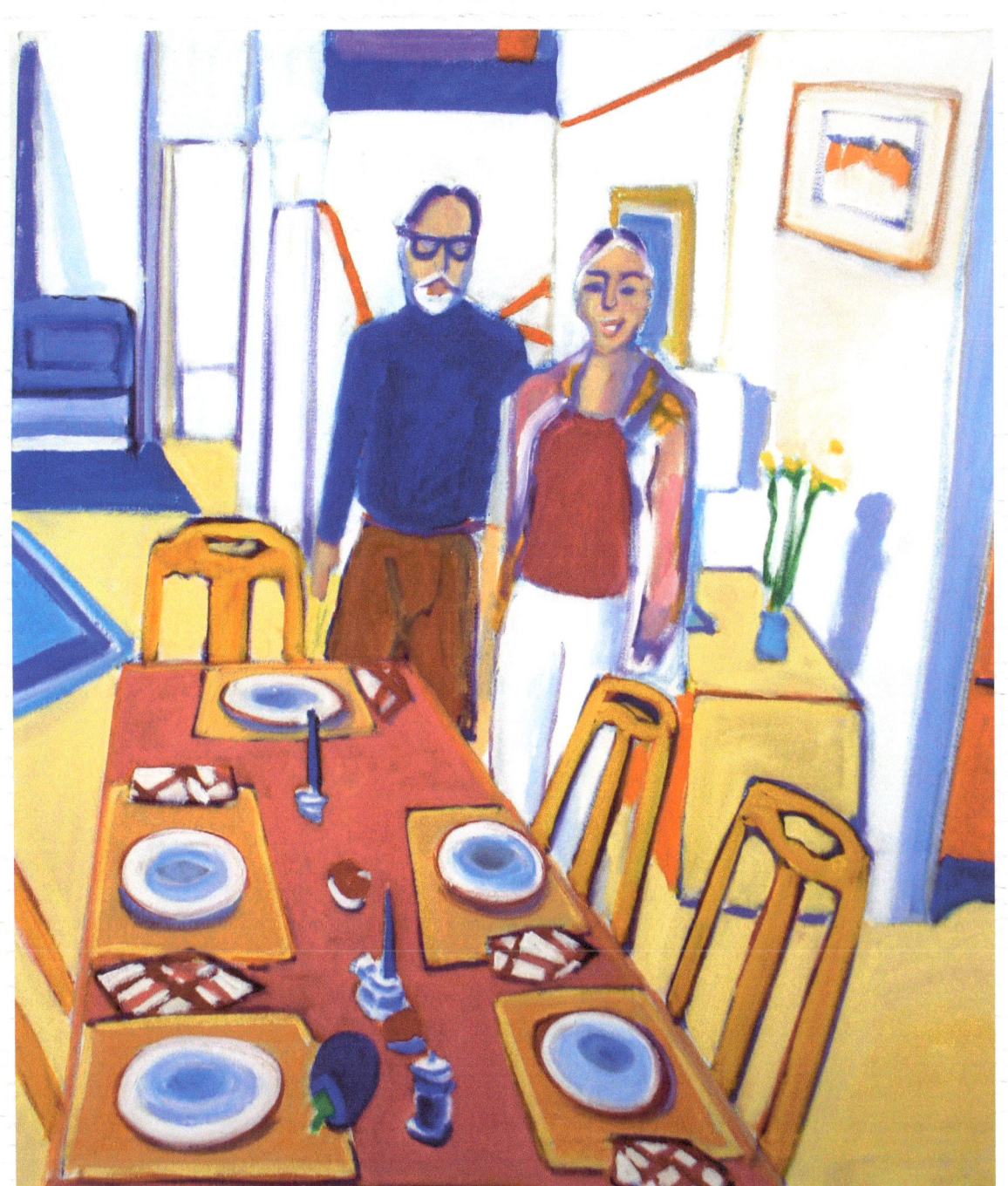

Roofs of Tompkins Square

It's early morning in our East Village apartment. The rising sun has cast purple shadows from doors standing sentry over roofs painted reflective silver. The shapes of the East Tenth Street buildings form a geometric counterpoint to the treetops of Tompkins Square Park.

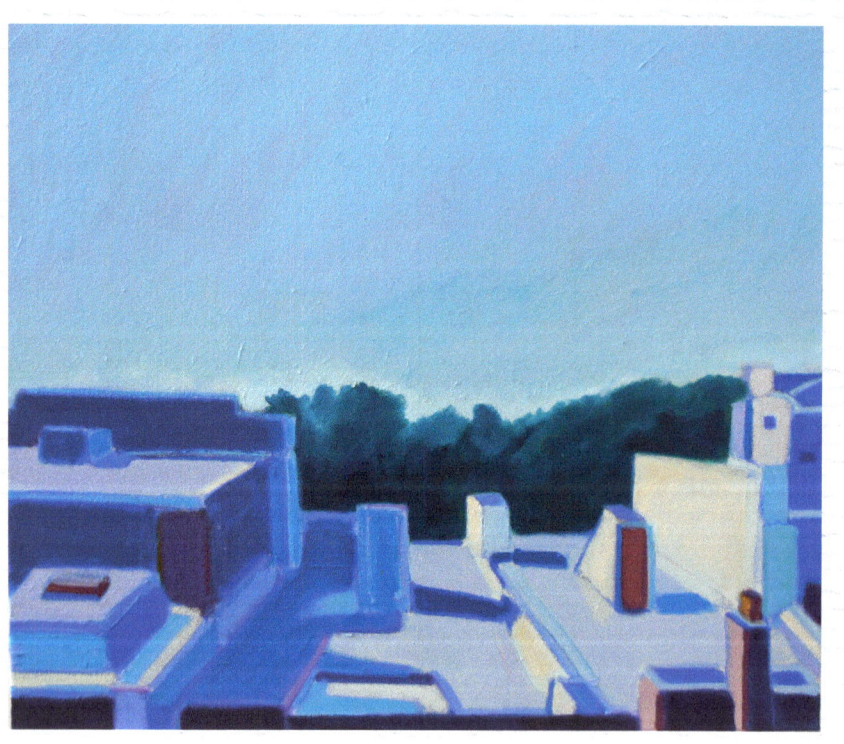

Looking North

Walking home in October just as a storm is lifting, I know that the view from our roof deck will be dramatic. When I get there, the storm clouds clear and push east, reflecting the glow of twilight settling in.

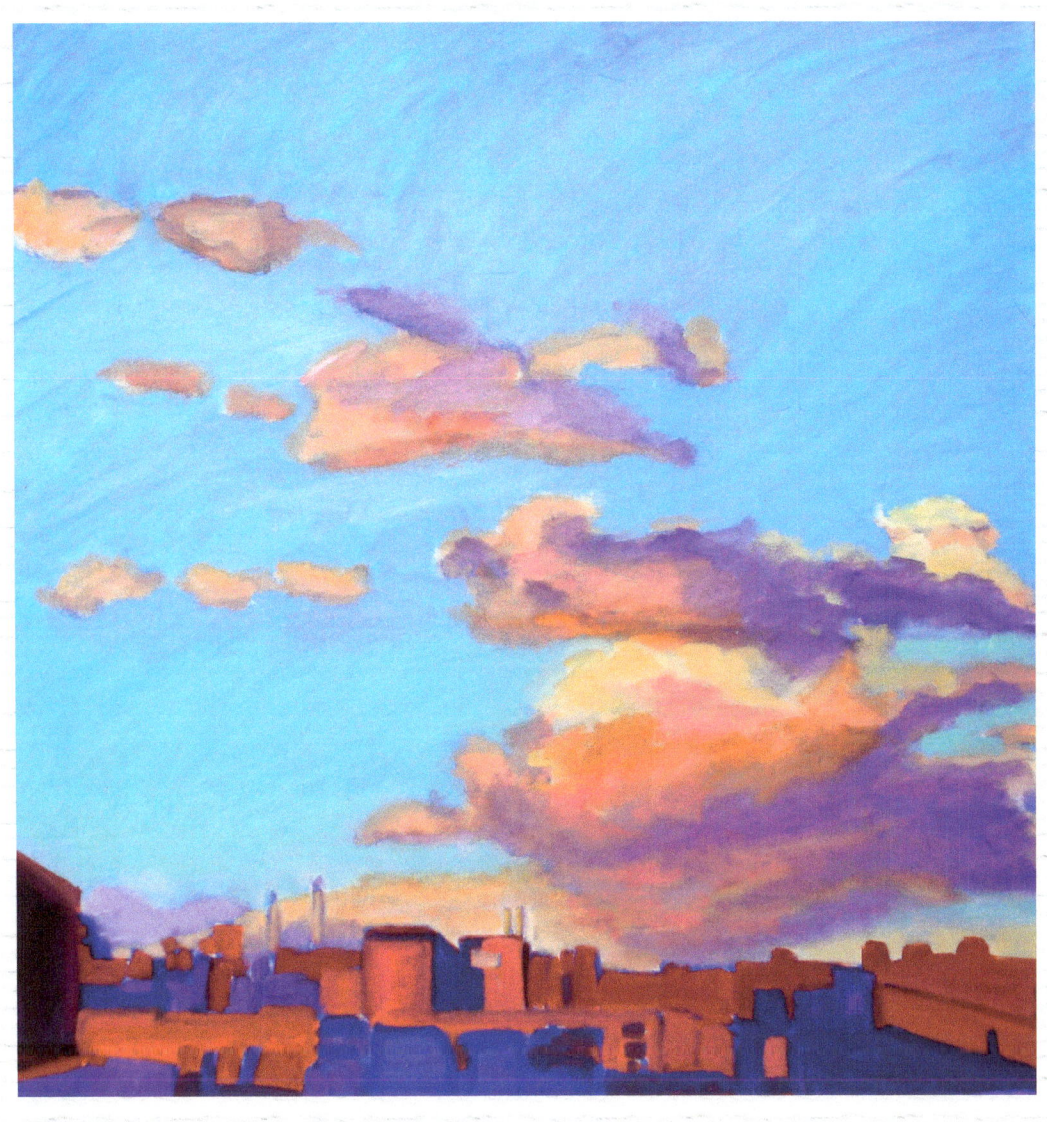

Patti O

Patti O'Shaughnessy, an interior designer and avid art collector, invites a group of friends to go on a gallery crawl in New York's Chelsea district. One stop is the Elizabeth Harris Gallery to see Julian Hatton's abstract paintings. As she pauses in front of this one, I am struck by how the colors so closely match her clothing. The gallery setting is spare, so not much distracts my eye. As always, Patti's wonderful sense of fun and excitement is evident as she immerses herself in the incredible art that surrounds us here in New York.

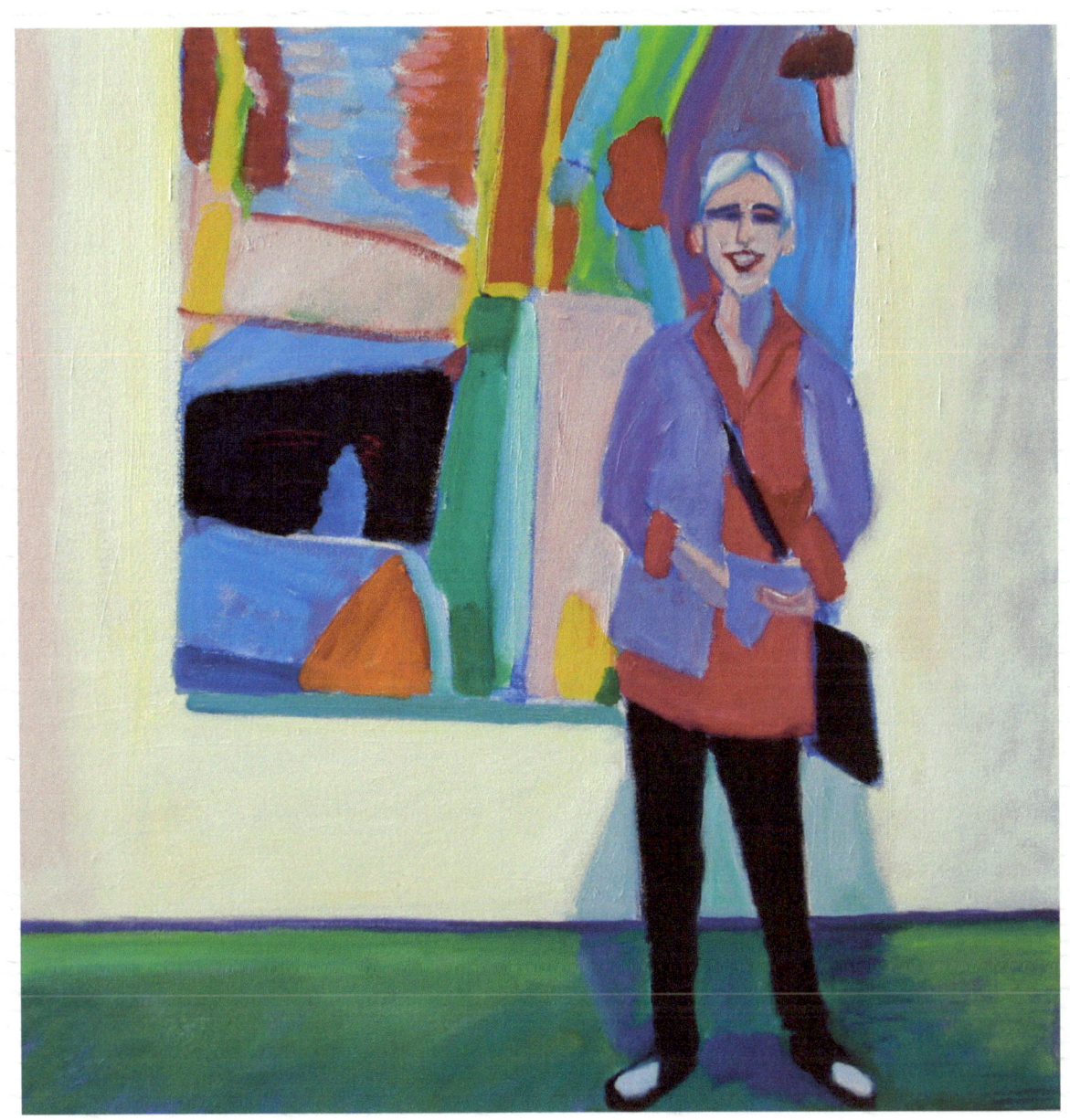

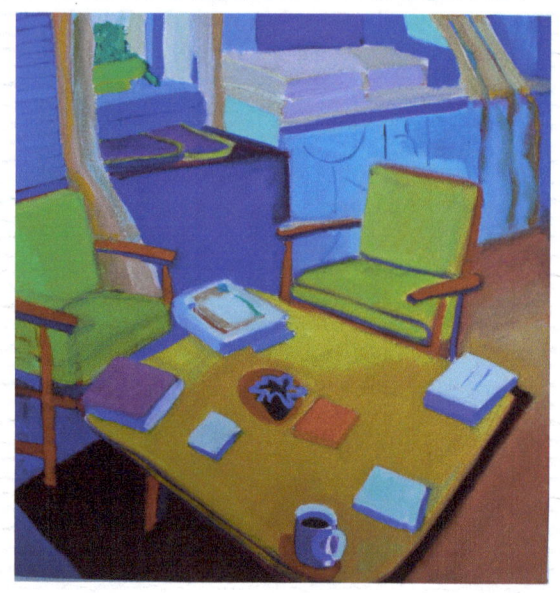

Living Room No. 26

Sitting on my living room couch, I suddenly see the chairs and coffee table as a still-life assemblage. My long-held concept of "what is a still life?" changes in an instant.

Michele, Reading

My sister, Michele, reads on our sofa. Our cat, Freddie, curls up next to her. One of my landscape paintings hangs above. Art books are stacked on end tables and topped with lamps that a friend created. Light streams in, illuminating a quiet Sunday morning.

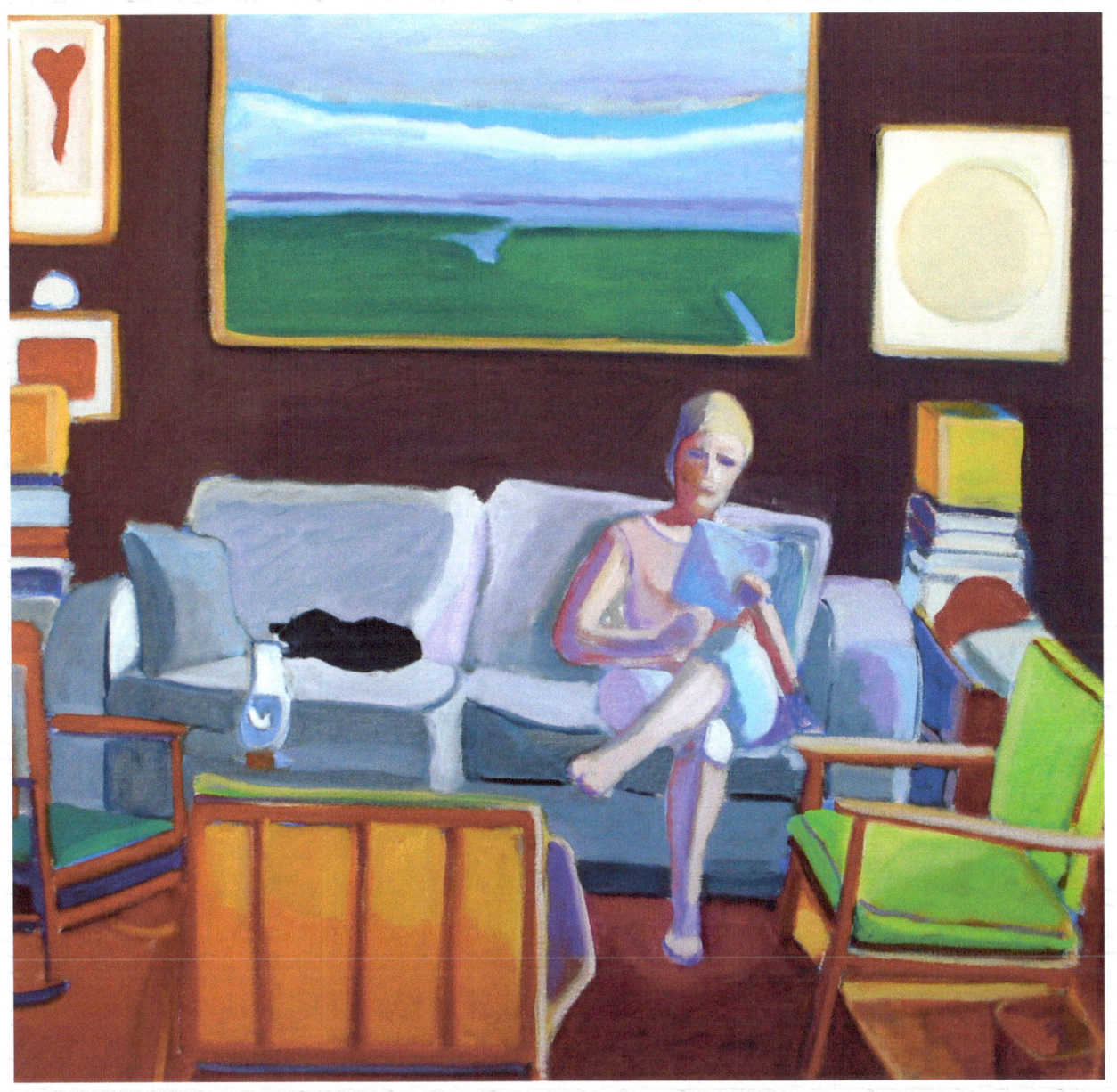

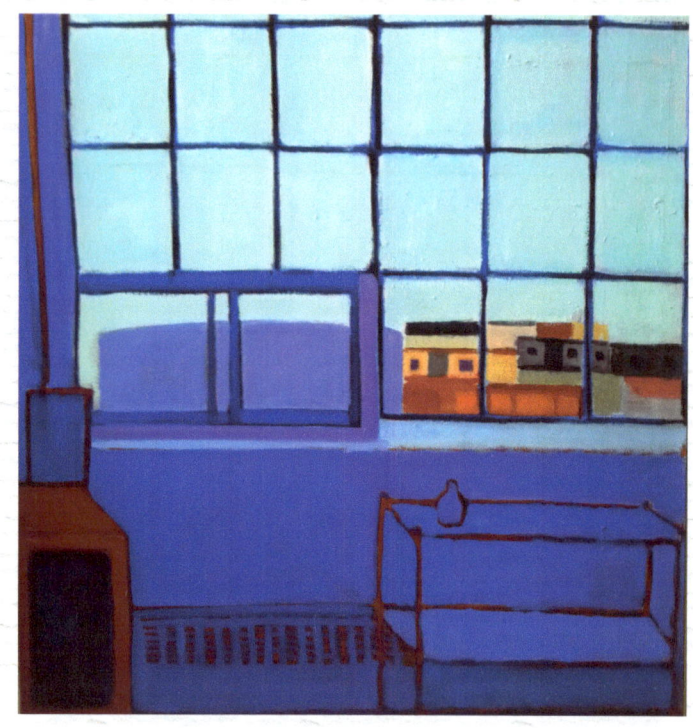

Bayside Window and Bayside Red Interior

I often paint still lifes in my studio at Bayside Fuel. One day I look past the backdrop of windows to the nearby fuel storage tanks and the cityscape of North Williamsburg behind. Again, my idea of "what is a still life?" expands – from a small studio tableau to the city beyond.

The cool blue north light filling my space during the day informs the color and tone of "Bayside Window." In contrast, the red light reflecting on the buildings of North Williamsburg when the sun goes down inspires the color palette of "Bayside Red Interior."

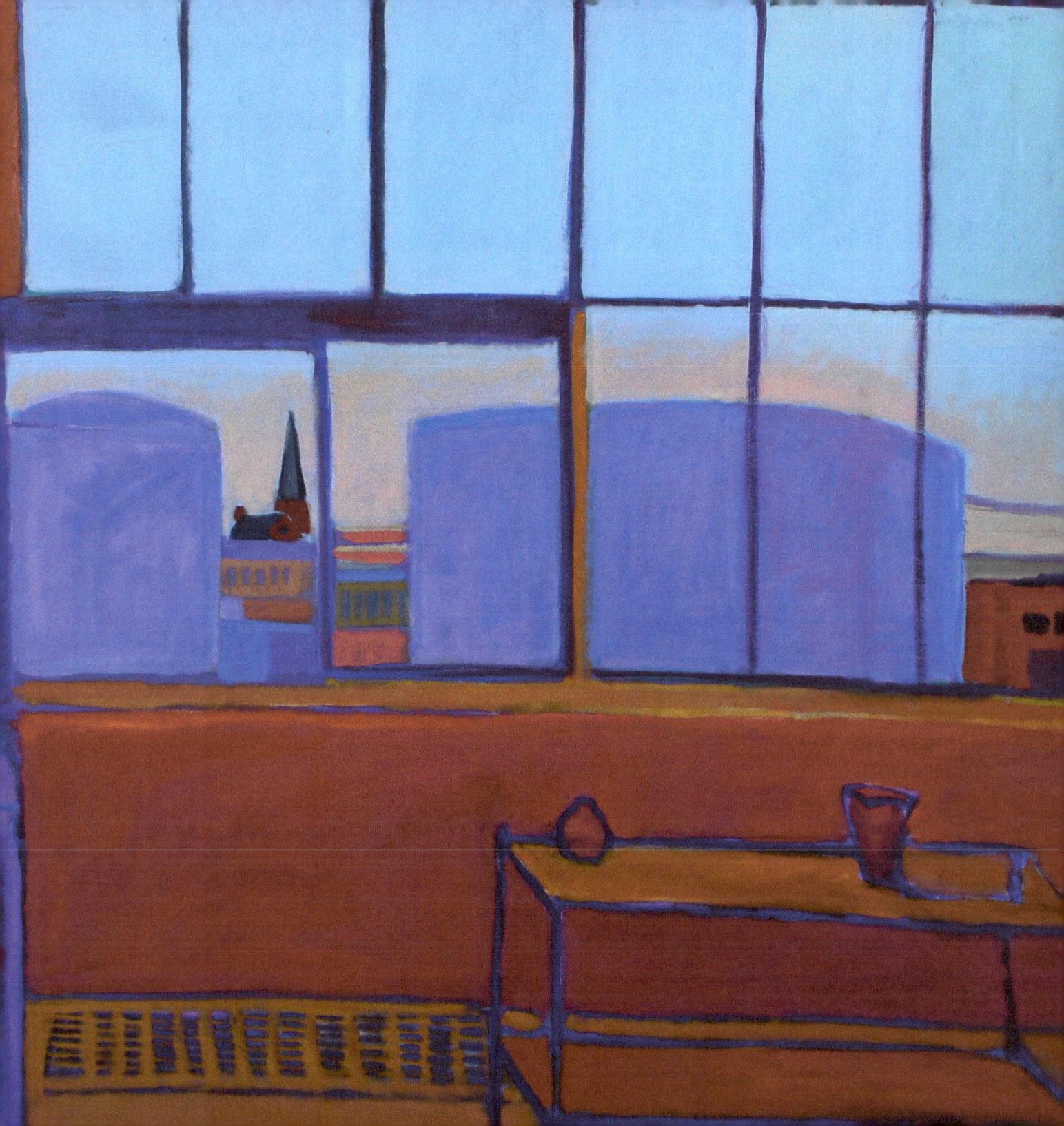

Bridge to Bridge

Outside my studio window, I begin to look more closely at Greenpoint, an industrial site. Newton Creek separates Greenpoint from Long Island City, and on a beautiful summer day the light, the creek, the sky and clouds become a wonderful landscape. I apply what I learned from painting simple landscapes to this more complex setting.

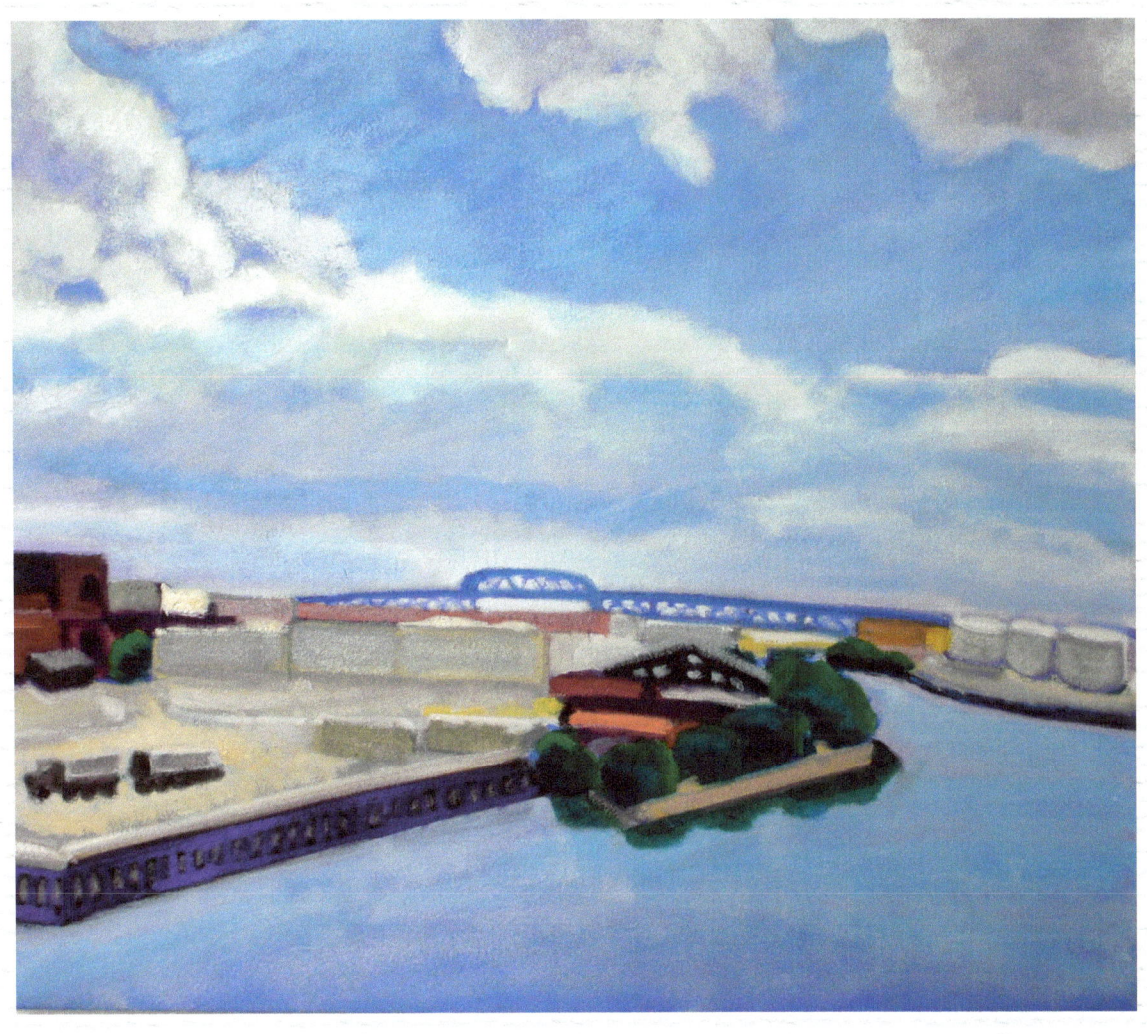

Andre

Sitting quietly in his Bucks County home, Andre is unaware that his wife, Linda, is taking a photograph, later to become this painting. Bright winter light coming through the window necessitates a hat to shield his eyes. A book and empty coffee cup on the table create, in a way, a still life. It is a moment of contemplative quiet for an artist whose work continues to inspire me.

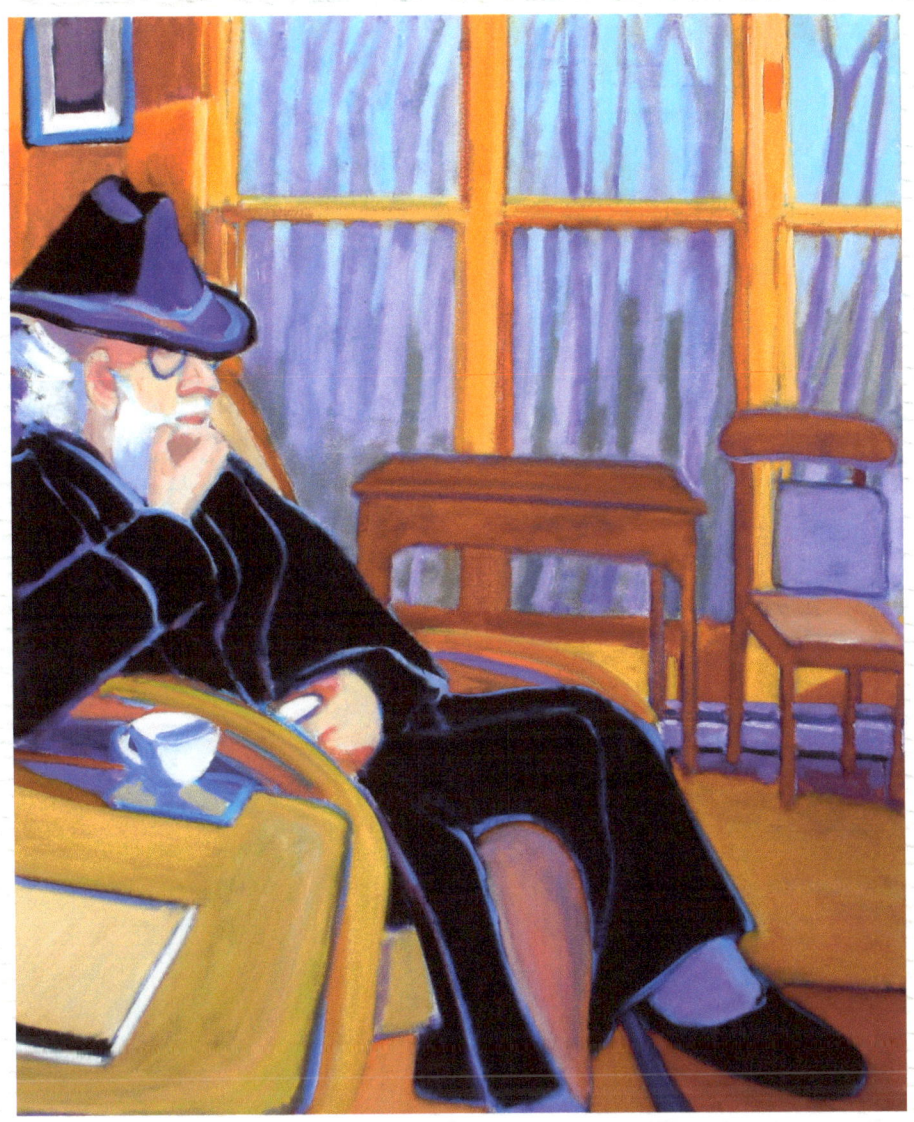

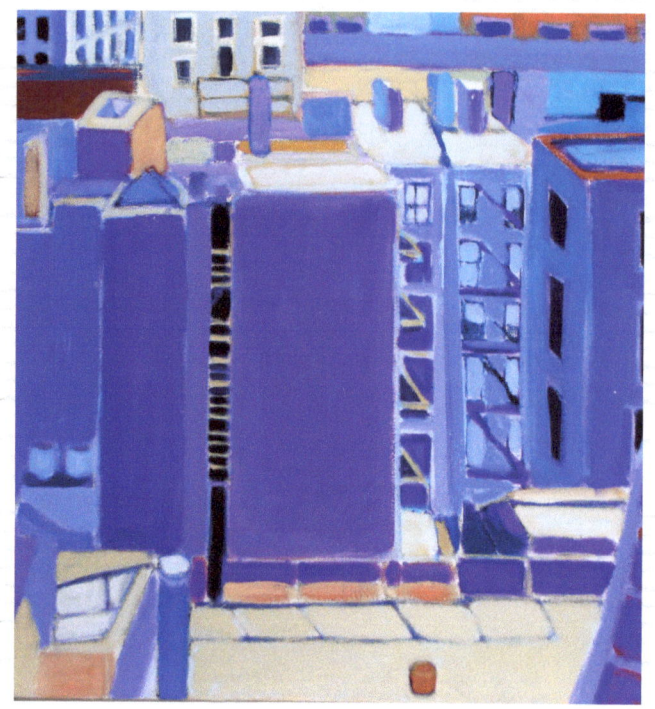

Bathhouse

A former bathhouse and the backs of tenement buildings on Avenue B create a patchwork of shadow, light and color.

Bayside View

The darkening sky of a storm moving in over a fuel depot create a kind of luminous beauty in an otherwise stark space.

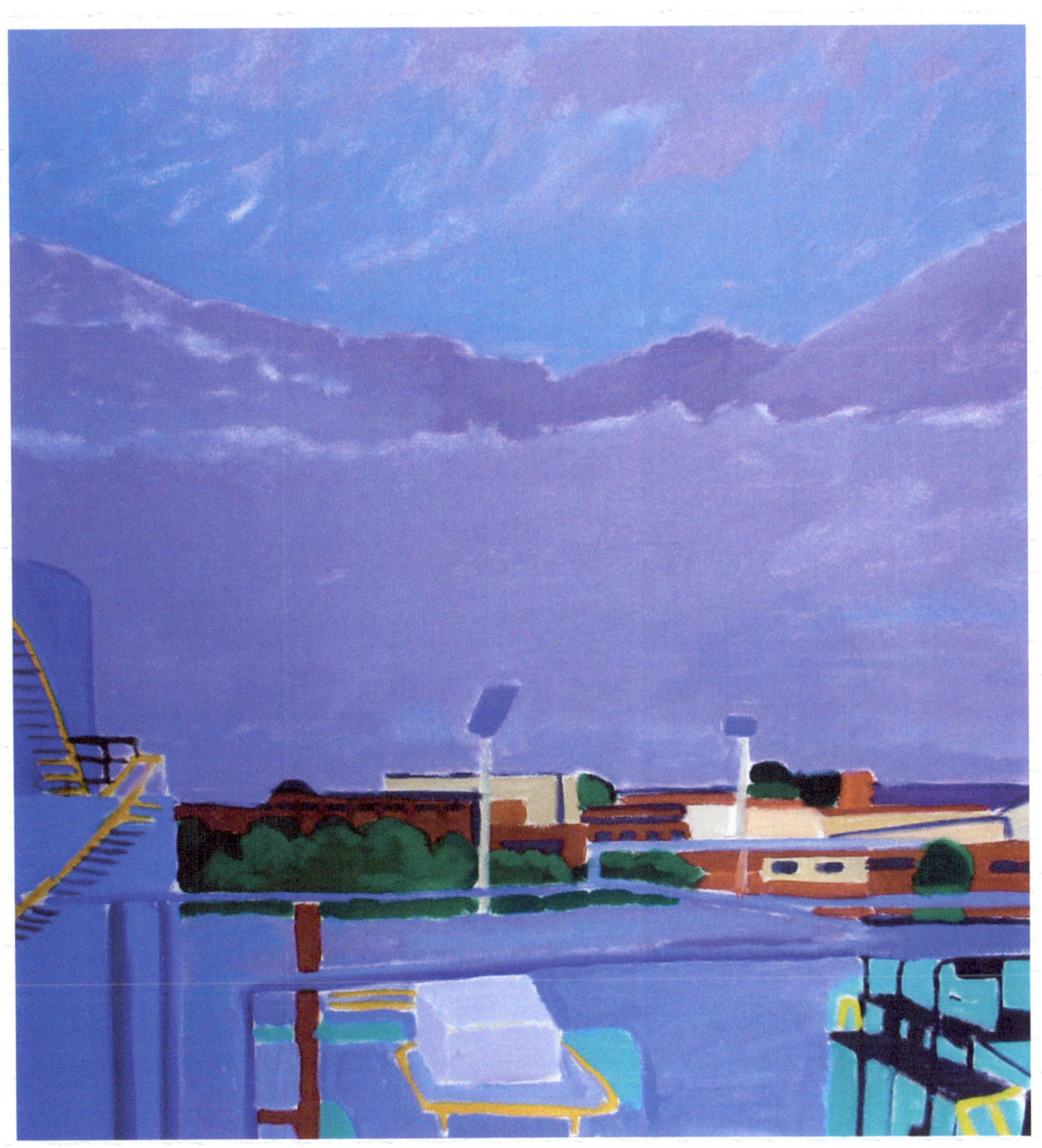

Pear

It's late fall when I place this single pear on my studio table. For the entire winter the fruit stays there as I paint its likeness over and over. When the light changes, the painting changes and, at last, it seems finished when early spring arrives. Its warmth banishes the cold winter light, and layers of paint produce the inner glow.

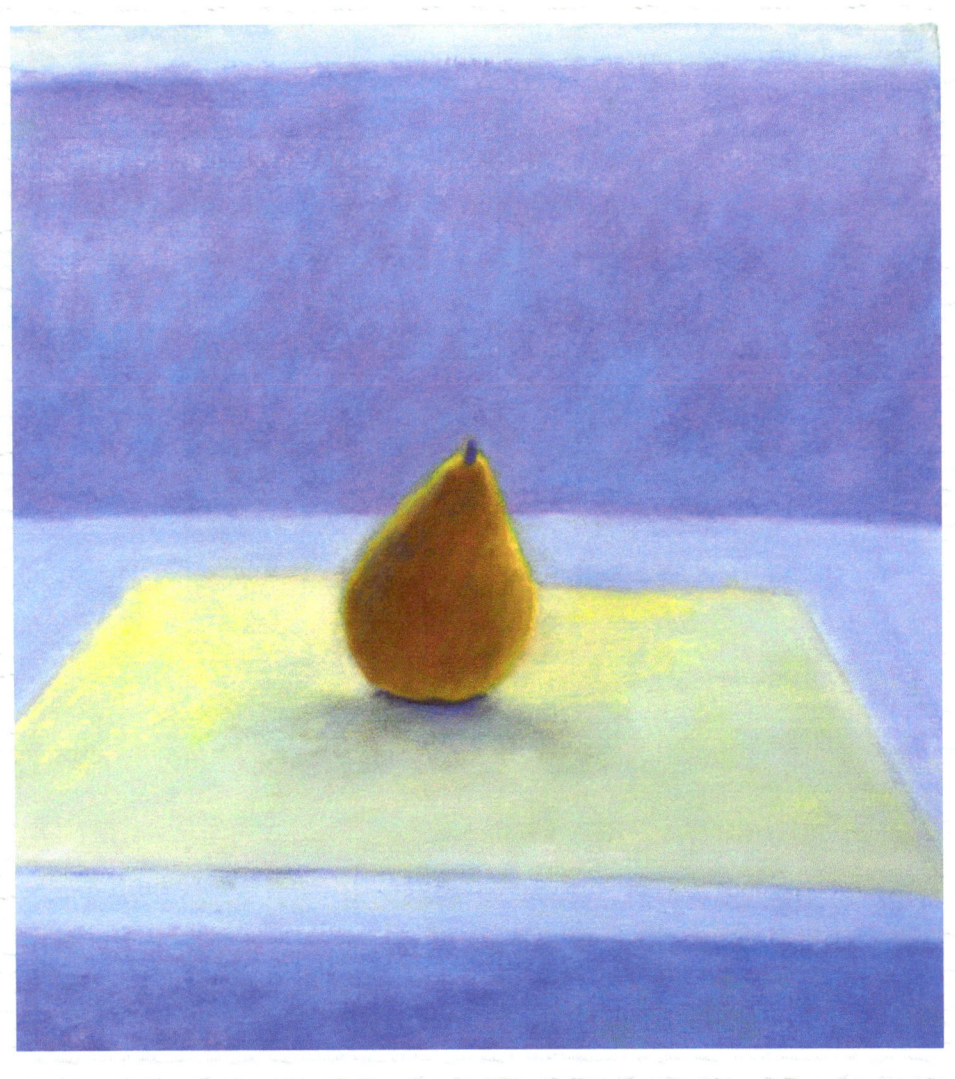

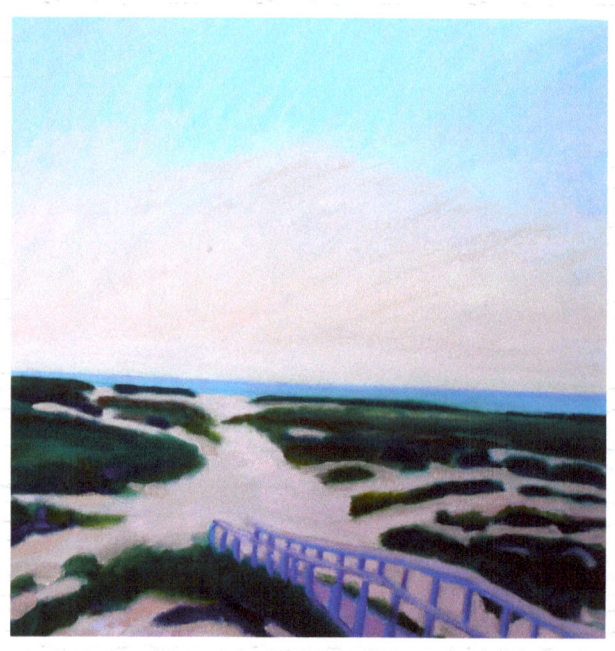

Boardwalk to the Pathway to the Dunes

An early summer day casts pale pink warmth on the white sand of Long Beach Island. The light on New Jersey barrier islands is unique – reflecting the eastern ocean waves and the western bayside waters.

North End

Barnegat Light beaches have benefitted from many years of dune restoration, holding fast even during Hurricane Sandy. Standing atop the dunes, you can see out to the sparkling blue waters of Barnegat Inlet, a passageway to the sea for generations of fishermen.

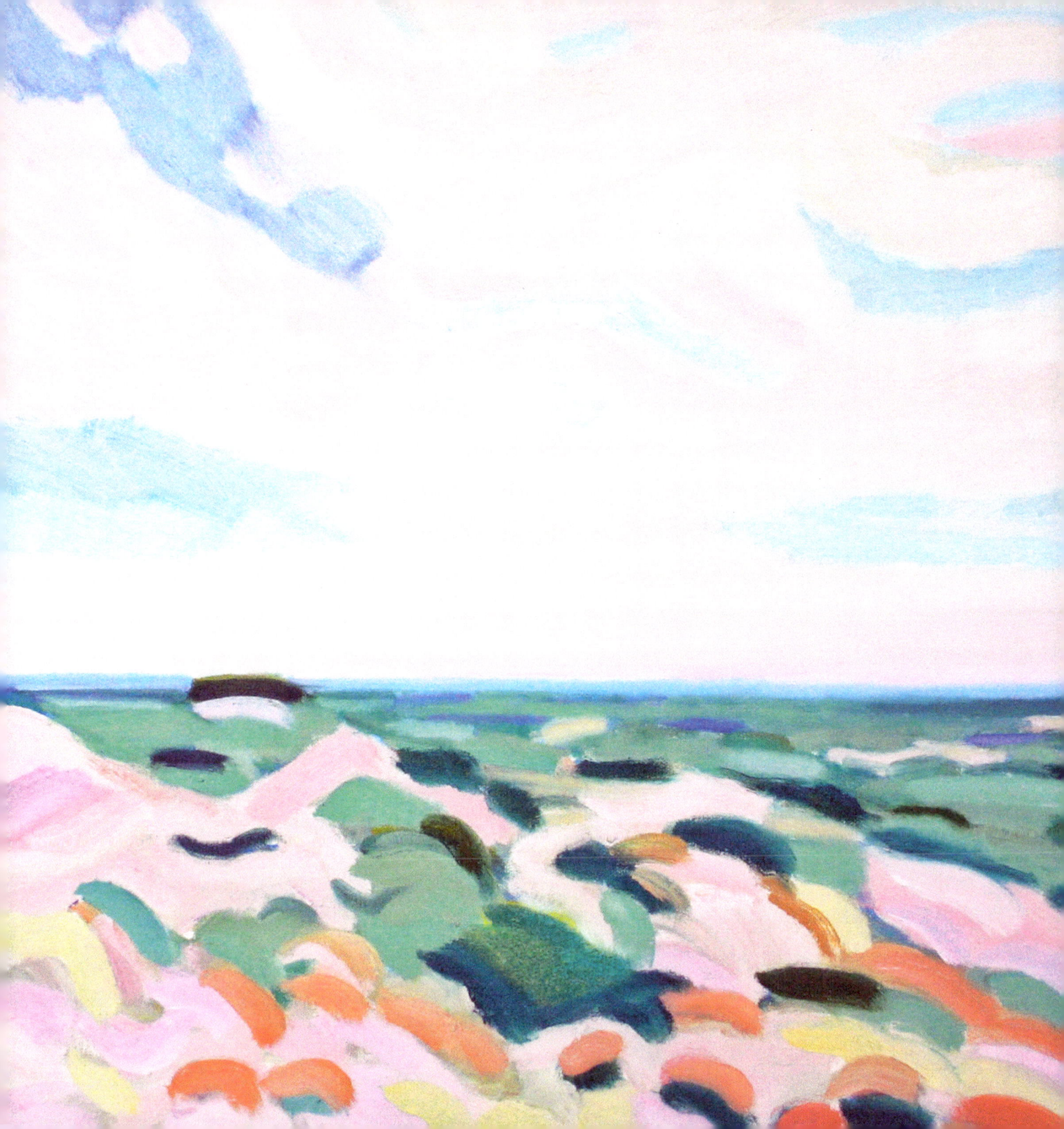

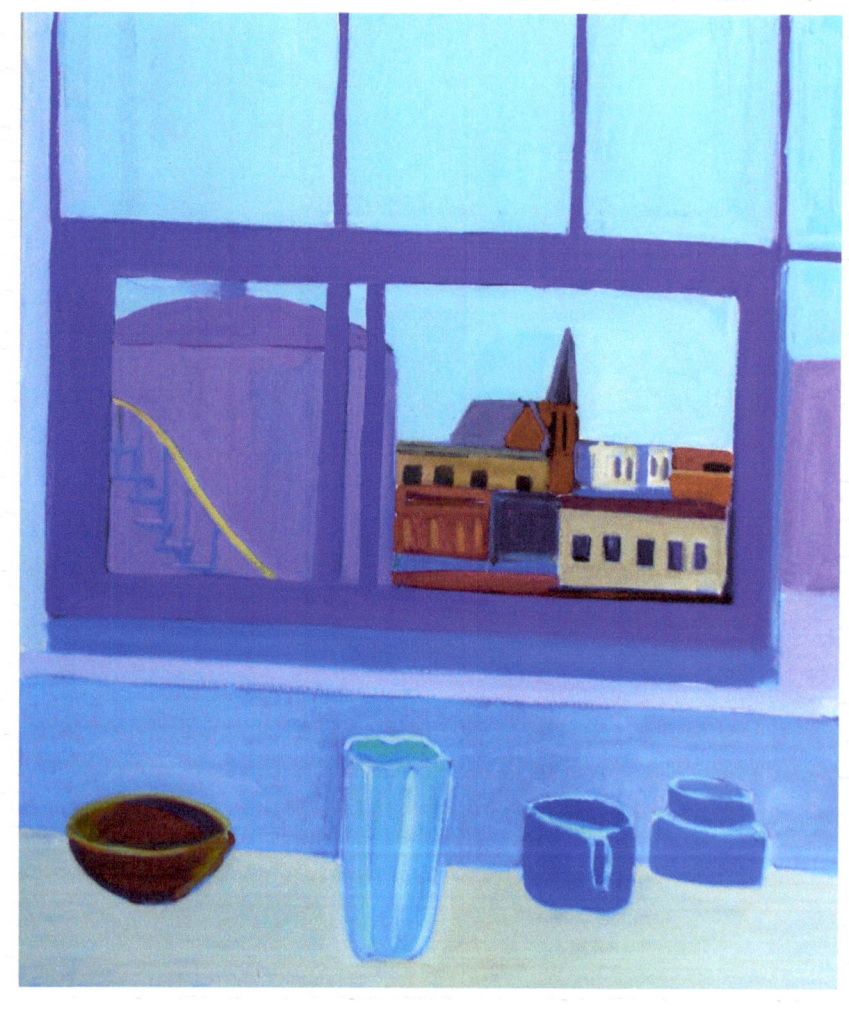

BOWL VASE CUP AND INTERIOR WITH PURPLE TULIPS

A still life's potential elements gather at my studio window, ready to appear in my many paintings and drawings. Here, the vessels' scale provides balance to the colossal silver tanks of Bayside Fuel.

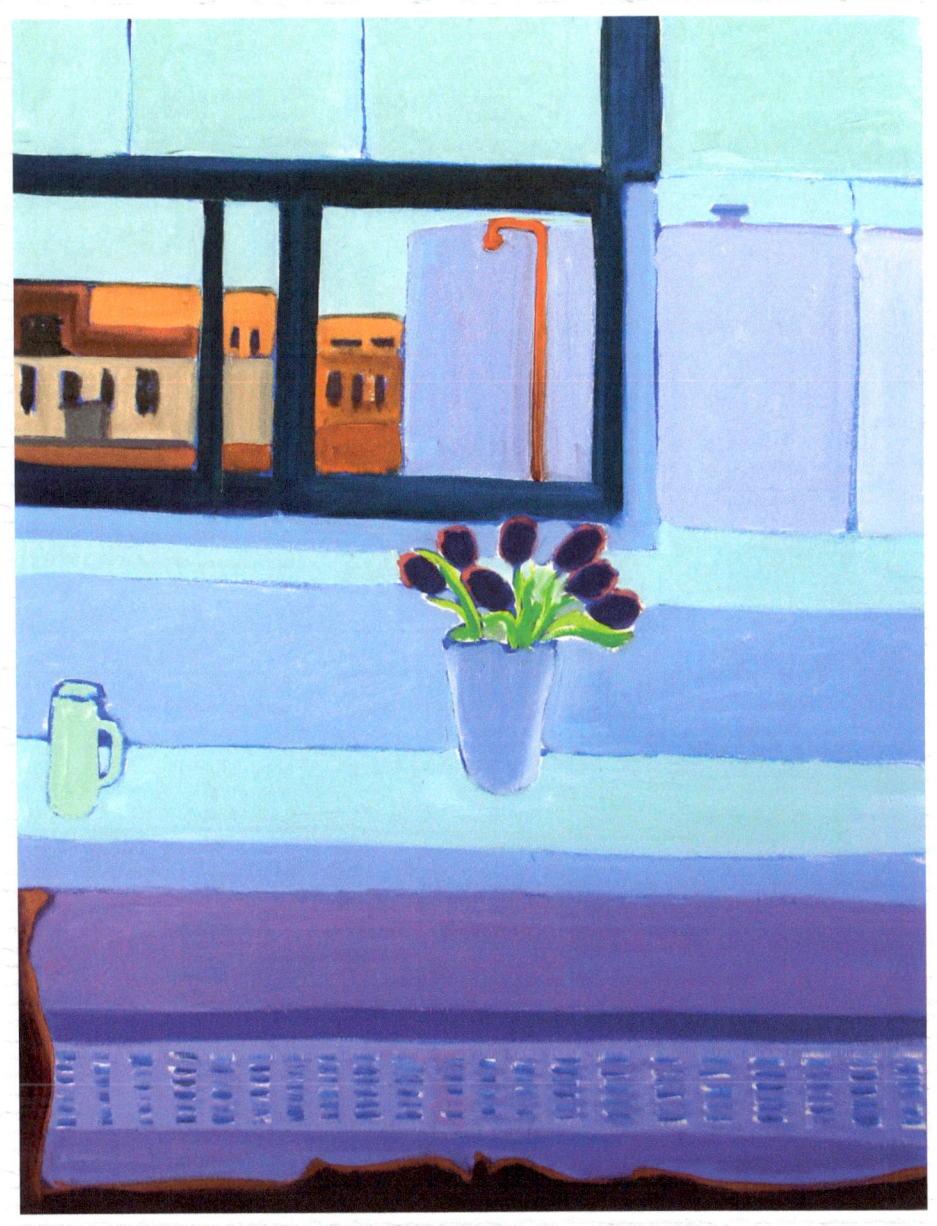

Backstreets, Lancaster

Bitterly cold, Lancaster has snow piled up into white rocks, refusing to melt even on a sunny January day. I find these back streets while strolling with my niece, Quinn McNichol, after lunch at a nearby restaurant.

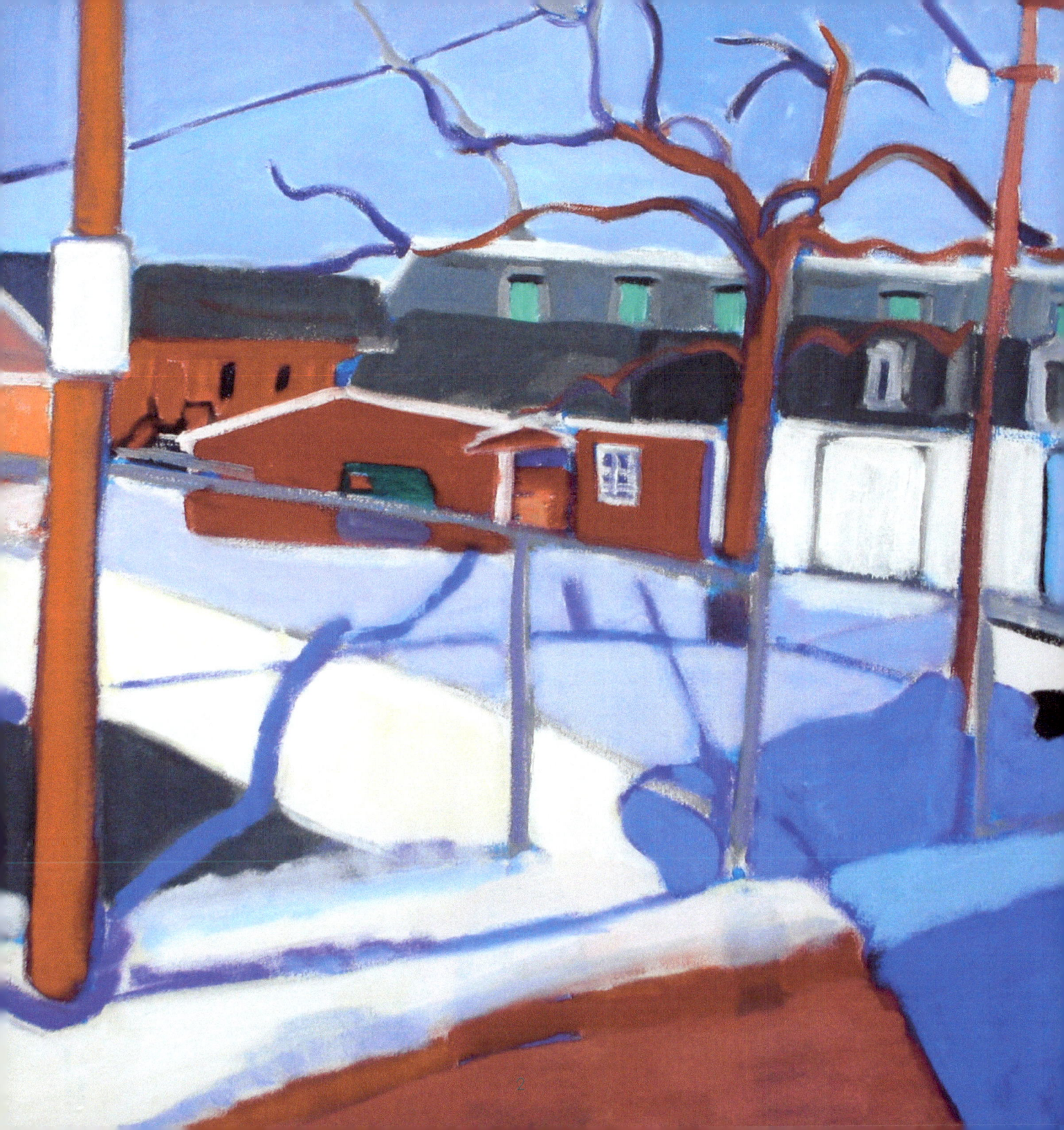

Morning Tea

It begins like many of our days. I'm at my desk, and my husband, Jim, is drinking his tea while reading an art magazine. But when I glance over and see the green of his shirt and the green of my painting above him, the image is so striking that I take a photo. Later, this quiet scene becomes a painting.

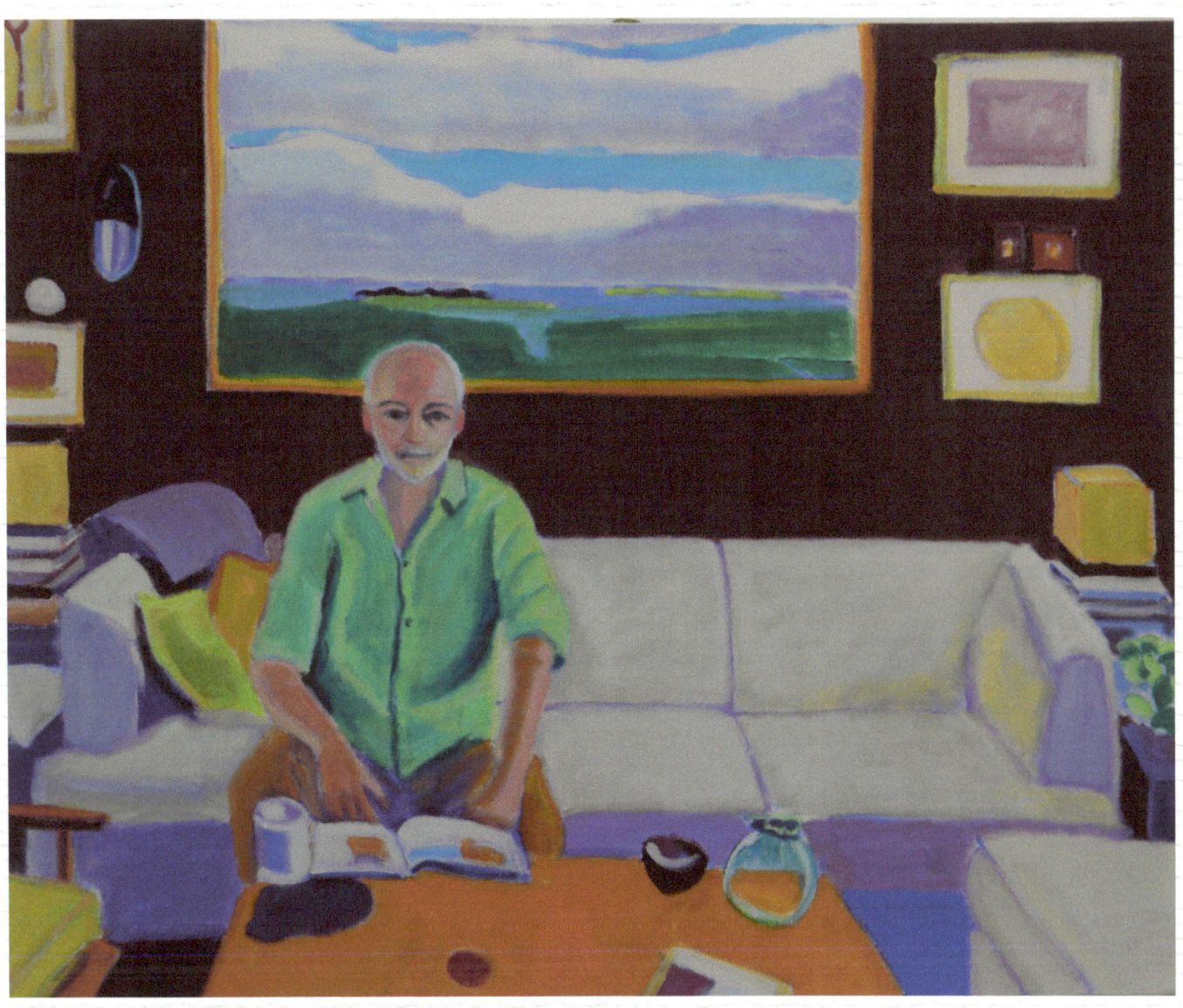

PAINTINGS
All paintings in this book are oil on canvas and are listed in order of appearance.

Quinn's Lancaster, 24" x 24", pg. 7
Six Flights Up, 20" x 20", pg. 9
Williamsburg Bridge, Springtime, 24" x 24", pg. 11
Wally In the Screened Porch, 30" x 28", pg. 13
Swallowtail Base, 12" x 12", pg. 15
Swallowtail View, 12" x 12", pg. 15
The Table Is Set, 28" x 32", pg. 17
Roofs of Tompkins Square, 22" x 26", pg. 18
Looking North, 24" x 24", pg. 19
Patti O, 20" x 20", pg. 21
Living Room No. 26, 20" x 24", pg. 22
Michele, Reading, 28" x 30", pg. 23
Bayside Window, 38" x 36", pg. 24
Bayside Red Interior, 42" x 42", pg. 25
Bridge to Bridge, 24" x 24", pg. 27
Andre, 24" x 24", pg. 29
Bathhouse, 20" x 20", pg. 30
Bayside View, 30" x 30", pg. 31
Pear, 20" x 19", pg. 33
Boardwalk to the Pathway to the Dunes, 20" x 20", pg. 34
North End, 20" x 20", pg. 35
Bowl Vase Cup, 32" x 28", pg. 36
Interior with Purple Tulips, 30" x 24", pg. 37
Backstreets, Lancaster, 24" x 24", pg. 39
Morning Tea, 24" x 30", pg. 41

www.ingramcontent.com/pod-product-compliance
Lightning Source LLC
Chambersburg PA
CBHW041317180526
45172CB00004B/1132